KEW POCKETBOOKS

HOUSEPLANTS

Curated by Brie Langley and Lydia White

Kew Publishing
Royal Botanic Gardens, Kew

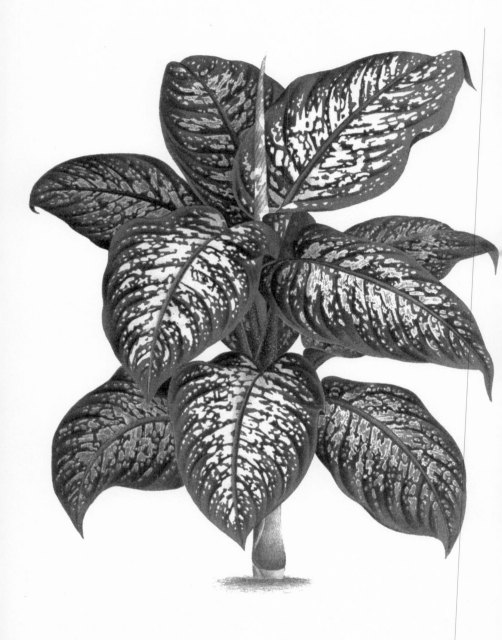

KEW HOLDS ONE OF THE LARGEST COLLECTIONS of botanical literature, art and archive material in the world. The library comprises 185,000 monographs and rare books, around 150,000 pamphlets, 5,000 serial titles and 25,000 maps. The Archives contain vast collections relating to Kew's long history as a global centre of plant information and a nationally important botanic garden including 7 million letters, lists, field notebooks, diaries and manuscript pages.

The Illustrations Collection comprises 200,000 watercolours, oils, prints and drawings, assembled over the last 200 years, forming an exceptional visual record of plants and fungi. Works include those of the great masters of botanical illustration such as Ehret, Redouté, the Bauer brothers, Thomas Duncanson, George Bond and Walter Hood Fitch. Our special collections include historic and contemporary originals prepared for *Curtis's Botanical Magazine*, the work of Margaret Meen, Thomas Baines, Margaret Mee, Joseph Hooker's Indian sketches, Edouard Morren's bromeliad paintings, 'Company School' works commissioned from Indian artists by Roxburgh, Wallich, Royle and others, and the Marianne North Collection, housed in the gallery named after her in Kew Gardens.

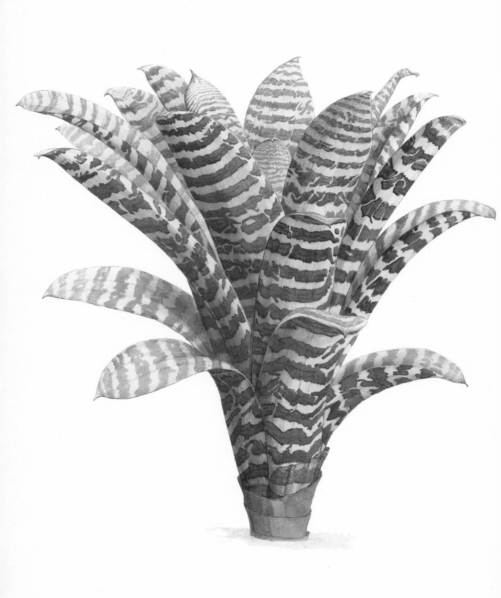

INTRODUCTION

GREENERY INSIDE THE HOME CREATES A
soothing and calm atmosphere that goes beyond looks
alone. An indoor jungle can lower stress and blood
pressure by reducing the production of stress hormones.
Just looking at the colour green or pictures of plants has
been shown to have a positive effect on our mood and
may even reduce pain. During the Covid-19 pandemic,
houseplants came to the fore as a distraction, relief
and medication for many. For me, caring for a plant is
an act of mindfulness and creates a sense of purpose
and connection to nature and the passing of time that
I cannot pinpoint. They somehow bring warmth to a
room, simply by their presence alone. But houseplants,
as we know them today, are an incredibly recent
phenomenon. The tropical plants that now bedeck our
homes were not always commercially available, for
starters. And even if they were, our homes were not
suitable to house plants all year round.

All plants require water, light and some level of warmth;
the last two being especially scarce indoors until the latter
half of the 20th century. The masses finally had access

to light with the repeal of the Window Tax in 1851, the creation of social housing after the Second World War, and the Clean Air Act of 1956. Now all that remained was heat. Once the Clean Air Act came into effect it limited the use of open fires. This led to central heating slowly becoming standard, which meant that plants could finally be grown in most homes. But there was one more barrier — money. Houseplants are, after all, a luxury. It took the economic booms of the sixties and eighties for the majority to be able to splash out. No longer the preserve of the rich and famous, everyone could now fill their homes with palms and ferns, and a few spider plants too!

This book describes a selection of houseplants to suit all levels of experience, available time, and budget. My hope is that you will find inspiration and knowledge within these printed leaves — and rid yourselves of the frustrating myth of 'green fingers'. There is no such thing as horticultural magic, there is only time, observation and luck. A plant will decide whether to live or die so do not blame yourself. Use that empty pot to try again with a new plant that suits you better. The best thing to do is to select houseplants that you like and that fit into your routine. An emotional bond or aesthetic appreciation will make it more likely that you observe and care for it; and if you tailor your plants to your availability, you will be more likely to keep up with the growth and watering demands of your little vegetable monsters. After that, it's all down to luck.

Today, houseplants are widely available to suit every budget and home, so don't let your fears hold you back. To help keep those damning thoughts at bay, here are a few pieces of general advice, for the novice especially, to get you started.

Watering

- Only water if the top 2 cm (1 in) of soil feels completely dry to the touch. Every plant is an individual and watering needs will change depending on your home and the season.

- Water to make all the soil equally wet, then let the water drain out of the pot to allow space in the soil for oxygen. Ideally, use a pot with holes and place a saucer underneath. If your pot does not have holes, keep the plant in a slightly smaller plastic pot with holes and hide this inside the solid one. You can even make your own pots from pieces of recycling. Remember to remove any excess water in the saucer or outer pot after a day or two, as no plant likes to sit wet. Once a month, water with diluted plant food.

- If you live in a hard water area, air plants and carnivorous plants should be watered with treated water. This could be rainwater, bottled water or twice-boiled tap water, anything to reduce the chlorine and calcium content.

- Generally, the larger the leaves the more water your plant will need. If your plant is grey or stores its own water, it will need much less as these signs tend to mean your plant is adapted to drought prone areas.

Position

- Keep plants somewhere that is easy to access, especially if you need to move large pots.

- Follow the instructions on how much light your plant needs. If it is too dark, your plants will become elongated and flimsy as they search for light.

- If you can only use space near a radiator or window, be aware how this may affect your plant. Radiators can dry out plants quickly, while windows can become very cold during winter nights.

- Only carnivorous plants need peat, otherwise use peat-free compost with lots of drainage (sand, grit or perlite).

Pests

- Get rid of insects by wiping them off with a damp cloth. If the insects fly, use a sticky trap where you see them most. Cut off mouldy and dead leaves as quickly as possible to stop the spread of disease. Any cleaning product suitable for babies can be used on plant tools.

And finally

- Buy nursery-grown plants from a reputable supplier that does not remove plants from the wild. Many houseplants are now endangered in the wild due to high demand.
- Some plants can cause allergic reactions or are poisonous. Always ask before you buy.

Brie Langley
Botanical Horticulturist, the Palm House
Royal Botanic Gardens, Kew

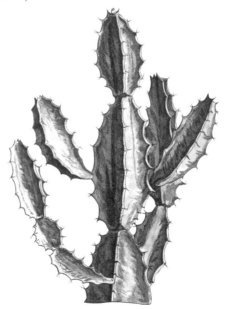

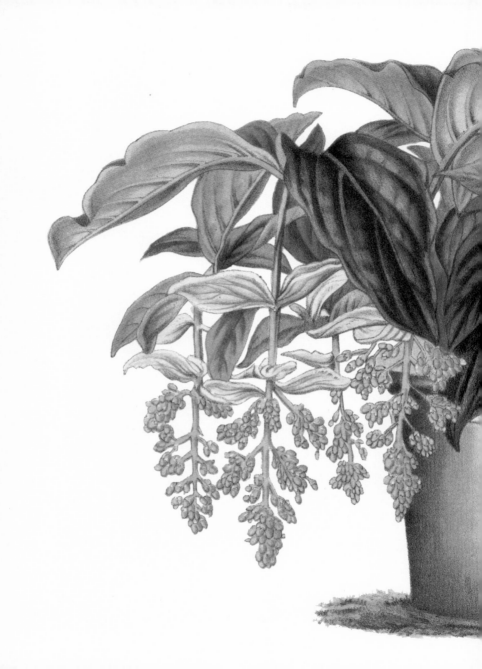

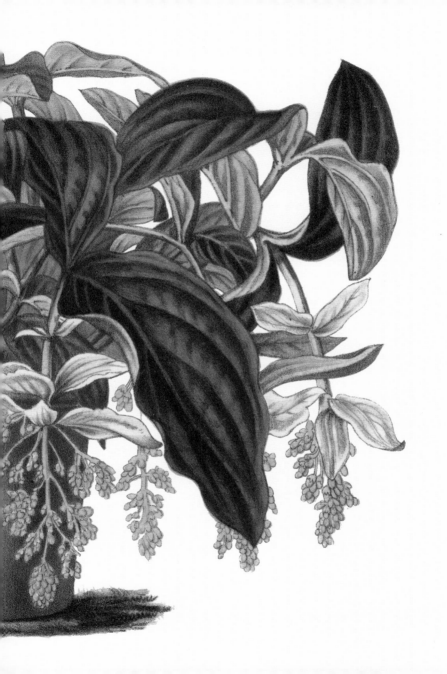

Alocasia zebrina

zebra plant
from *Flore des Serres et des
Jardins de l'Europe*, 1862

Incredibly sculptural, this plant is for those who
wish to make a statement. The perfect plant
for a busy gardener, it will never grow too tall,
prefers to remain in a small pot and does not
like too much water.

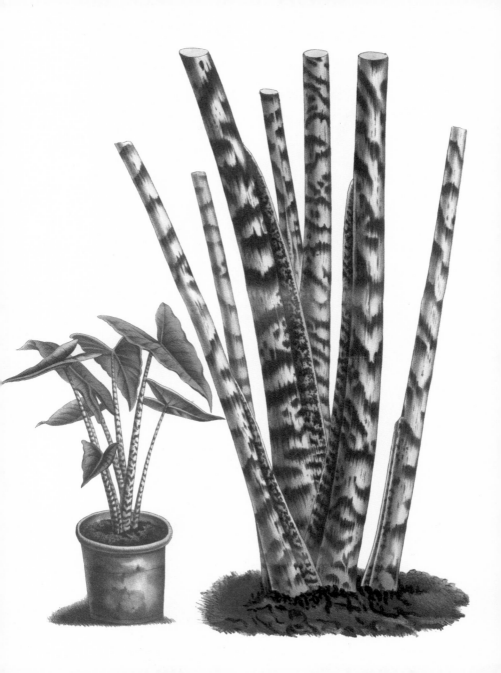

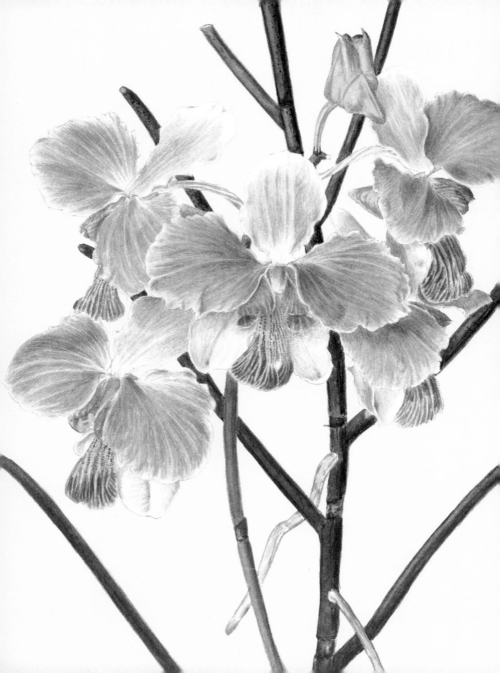

Vanda species

vanda

by John Day from John Day Scrapbooks,
Kew Collection, 1884

If you're up for a challenge, these tropical Asian orchids will reward you with incredibly large blooms for months. The trick is to keep the roots moist and the foliage dry and away from direct sun. If you are worried about damp at home, try keeping the roots in a glass jar or plastic bag to contain the humidity.

Haworthiopsis fasciata

zebra plant
from Joseph Franz von Jacquin
*Eclogae Plantarum Rariorum aut
Minus Cognitarum*, 1811–44

Haworthiopsis (previously known as
Haworthia) come in many shapes and sizes, but
their flowers are always the same. The incredibly
delicate white flowers on long "fishing rods" are
produced in late winter to early spring and will
completely take you by surprise. If possible,
always keep *Haworthiopsis* in shallow pots
to avoid root rot.

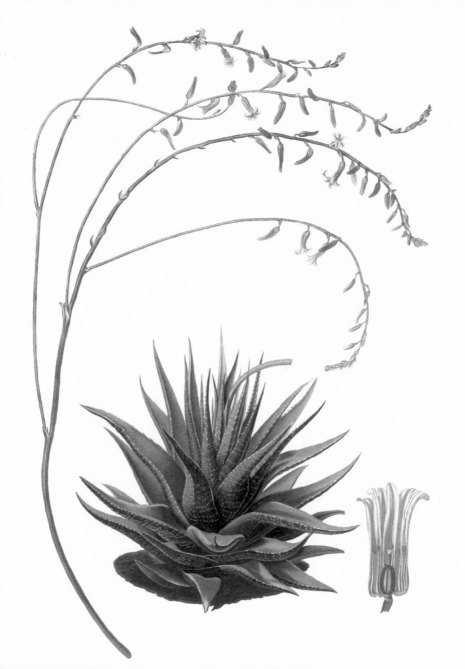

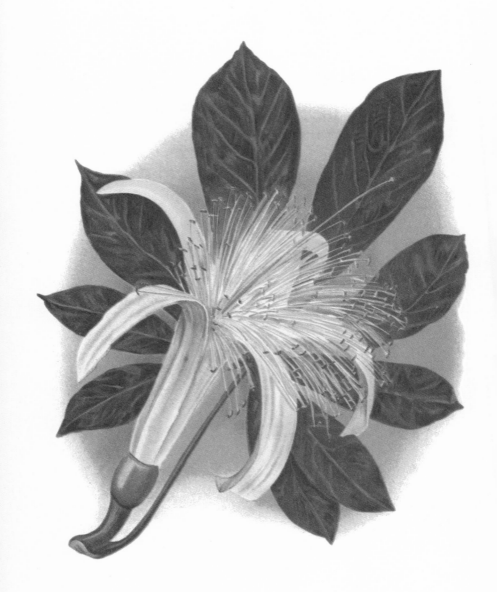

Pachira aquatica

money tree, French peanut
from *Gartenflora*, 1896

Although it may not look it, this plant is
actually related to the cacao tree. It has huge
white flowers that look like a peeled banana
when fully open and will eventually form a
small capsule that resembles a cacao pod.
Unfortunately, none of this tree is edible and
it very rarely flowers in the home.

Chlorophytum capense

bracket plant
from *Flore des Serres et des
Jardins de l'Europe,* 1875

For those who want the spider plant look
without the mess, the bracket plant is far more
tame than the 70s classic. Simply tear away any
sizeable "pups" that develop around the base
to spread the love.

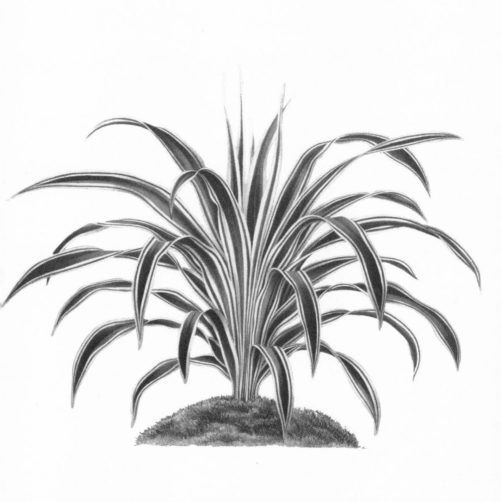

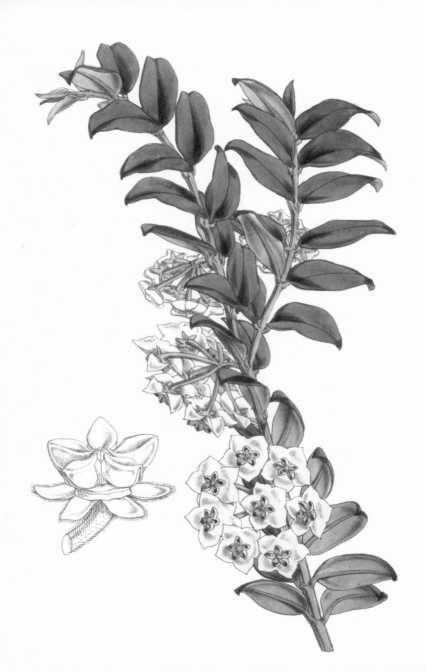

Hoya lanceolata

by Walter Hood Fitch from
Curtis's Botanical Magazine, 1848

———————

This sweet-smelling climber is very long-lived,
so it is well worth training into a desirable
shape and size. Whichever structure you use as
a frame, always try to exploit the plant's natural
twining habit to keep it in place. You can use
string or wire twist ties as a temporary
measure, but they become a nesting area
for pests if left too long.

Ananas comosus

pineapple
from *Annales de Flore et de Pomone*, 1833

The stone folly, the Pineapple of Dunmore, is
an extreme example of how revered this exotic
fruit was in the 18th century. So rare that only
the richest could view, never mind eat the
fruit; pineapples came to symbolise power
and status. We can now grow them easily
on our windowsills.

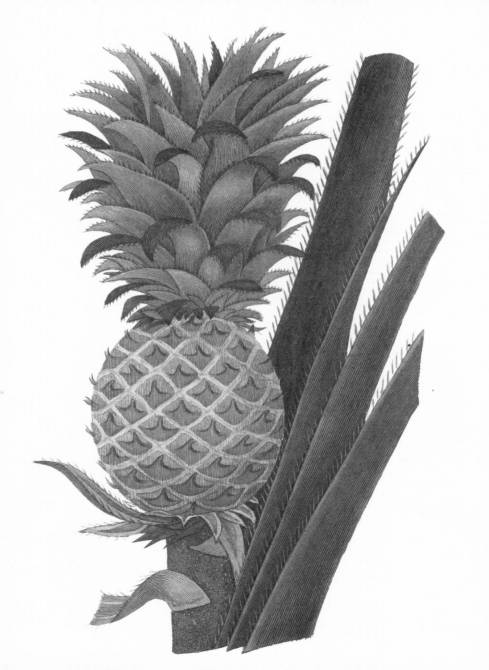

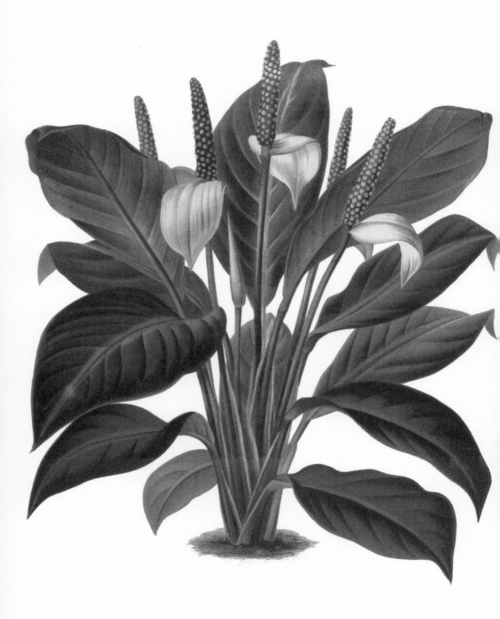

Spathiphyllum floribundum

peace lily
from *l'Illustration Horticole*, 1874

The peace lily is famous for its large white flowers, which last for many months at a time. The spadix, or upright cylinder of flowers, is surrounded by a large white spathe, a papery hood that makes the spadix shine out against the dark leaves below.

Howea forsteriana

Kentia palm
by Pieter de Pannemaeker from
Oswald Charles Eugene de Kerchove de
Denterghem *Les Palmiers*, 1878

Conserve a rare plant in your living room!
Native to Lord Howe Island, an Australian
island in the Tasman Sea, this vulnerable palm
is now protected and only grown for trade under
a strict protocol, helping to protect this species
for generations to come.

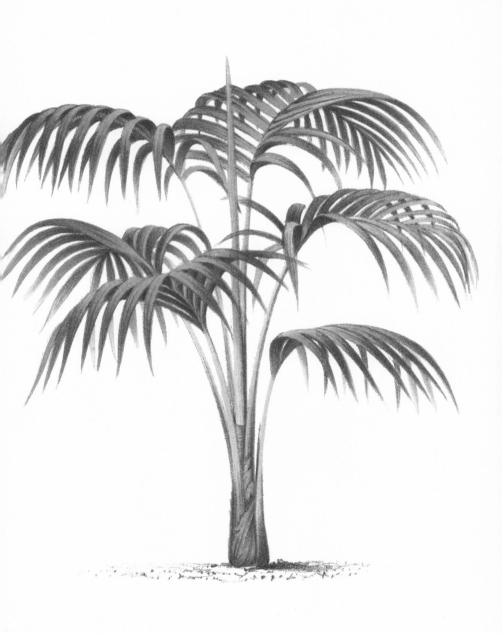

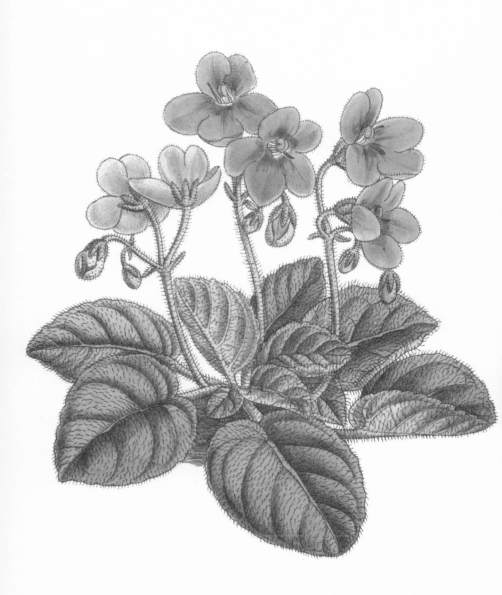

Saintpaulia ionantha

African violet
by Matilda Smith from
Curtis's Botanical Magazine, 1895

―――――――――

Incredibly popular in the 1980s, this constantly
flowering houseplant is due a comeback.
Commonly known as African violets, they hail
from Tanzania and can take a while to settle
in the home. Water consistently, always from
the base, and try different positions around the
house if it seems unhappy.

Tillandsia usneoides

Spanish moss
by Walter Hood Fitch from
Curtis's Botanical Magazine, 1877

Air plants are covered in tiny hairs, called
trichomes, that take in moisture and nutrients
from the air. Either mist daily or soak overnight
in a bucket of treated water once a week.
Keep in a place where there is ample light — a
bathroom is ideal — and keep an eye out for
the tiny flowers.

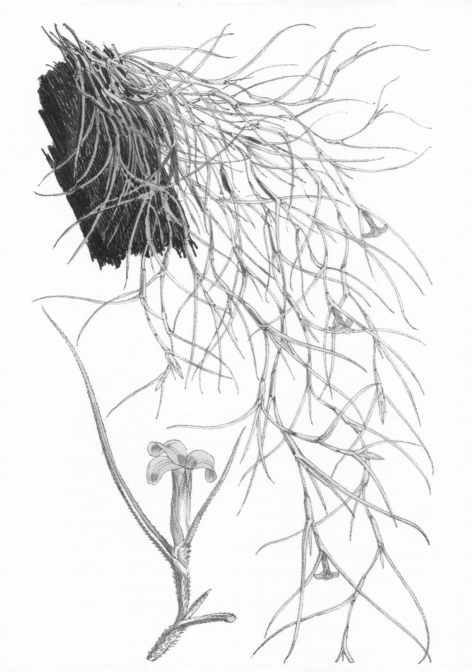

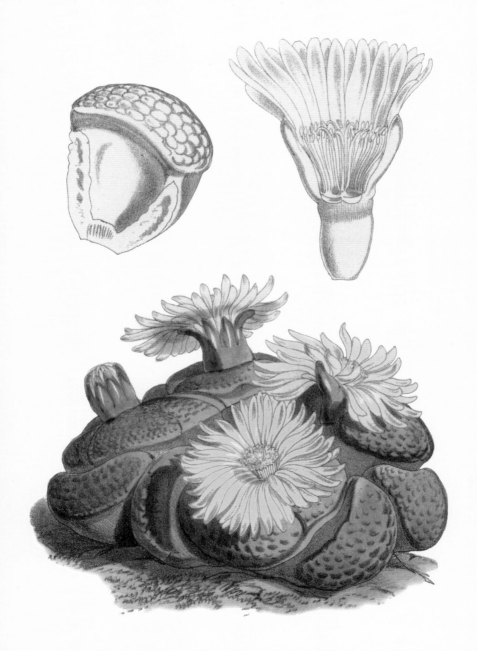

Lithops species

living stone
by Walter Hood Fitch from
Curtis's Botanical Magazine, 1874

These remarkable plants have evolved to
resemble the pebbles around them to avoid
being eaten by predators. When ready, the
"living stones" produce flowers the size of
their entire body, in bright pinks, yellows and
oranges. Keep on a sunny windowsill in very
well drained soil.

N⁰ 13

Phlebodium aureum

hare-foot fern
from Edward Joseph Lowe
Ferns: British and exotic, 1839

This serene-looking plant is often sold as an
air purifier, as it has been demonstrated to
extract certain toxins from the air. Even more
interesting, trials are now showing it may have
a potential use as a sunscreen when taken
in pill form.

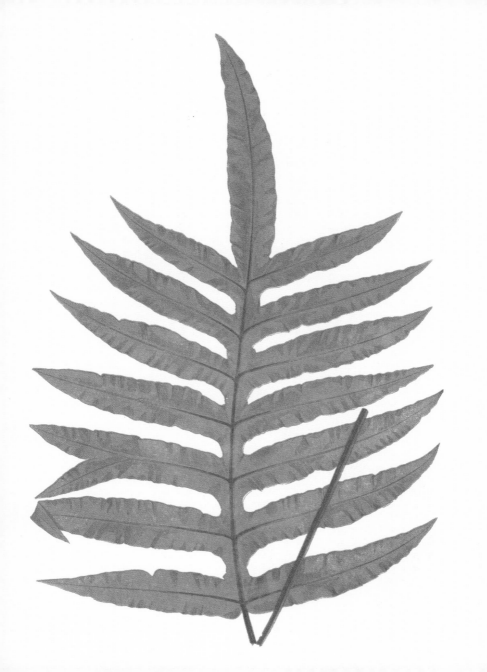

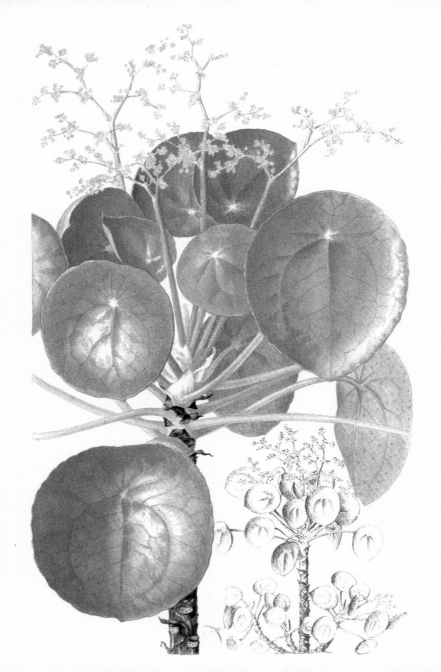

Pilea peperomioides

Chinese money tree

by Christabel King from
Curtis's Botanical Magazine, 1984

The Chinese money tree has long been a
symbol of luck and wealth. According to feng
shui, the plant should be positioned in the
most northwest corner of a room for
maximum effect.

N° 15

Euphorbia lacei

from Caspar Commelijn
Praeludia Botanica, 1703

Traditionally used as a hedging plant in Gabon,
this is as stately a succulent as you will ever
come across. *E. lacei* has an incredible presence
in a room, particularly when
mature, and is perfect for a cool, dry spot
with lots of sun.

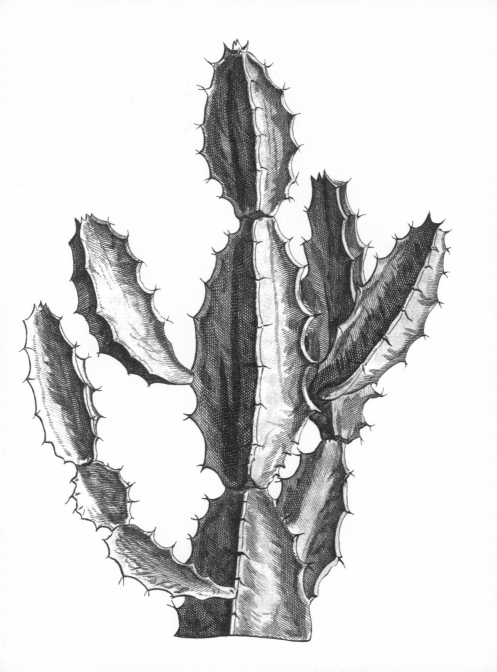

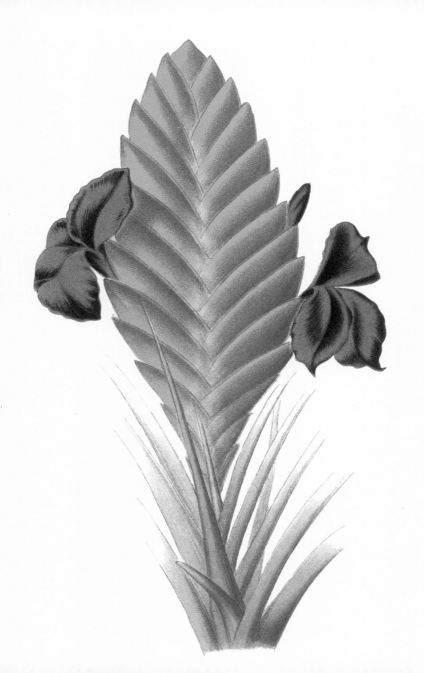

Tillandsia cyanea

pink quill
from *La Belgique Horticole*, 1869

This plant, commonly known as a pink quill,
illustrates perfectly why bromeliads make
brilliant houseplants. The bright pink "feather"
is a bract, or decorative leaf. This solid structure
lasts for years at a time and serves to attract
hummingbirds to the dark blue flowers which
appear along its border.

Ficus benjamina

weeping fig

from *Curtis's Botanical Magazine*, 1834

The weeping fig brings an air of calm and serenity to a room, which is often lost in its usual habitat — the back corner of an office. For an added touch, place it somewhere the breeze can tickle its elegant leaves. The sound this produces and the movement of light through its leaves are a great focus for mindful meditation.

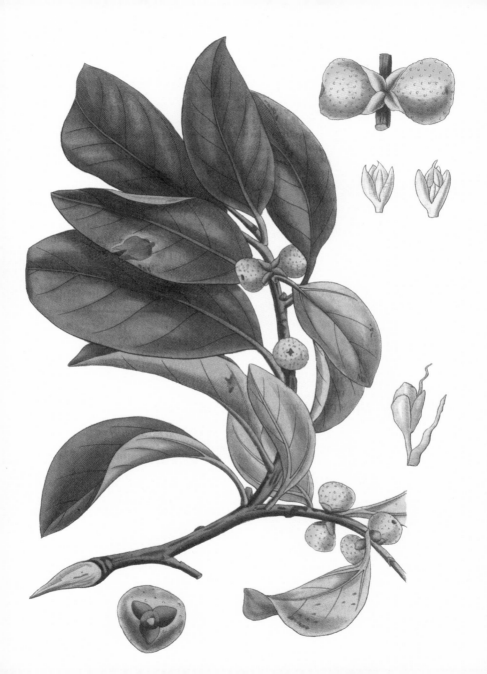

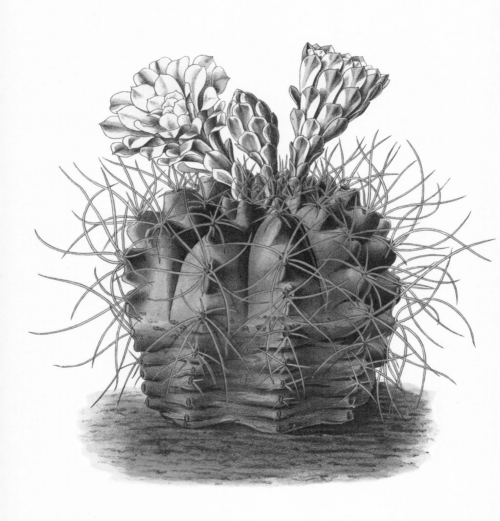

Gymnocalycium anisitsii

from Karl Schumann, Max Gürke, and
Friedrich Vaupel *Blühende Kakteen
(Iconographia Cactacearum)*, 1904–21

Cacti are strange beasts and do not act as other
plants would. If they start to look ill, stop
watering them, as this will make them worse.
Leave for a month and then give them a little
water. If they take it in then you know you can
begin watering as normal again.

Epipremnum aureum

golden pothos
from *l'Illustration Horticole*, 1871

This beautiful Araceae climber makes an
inexpensive stand-in for the variegated
Monstera that is so in demand right now. Be
aware that some Araceae do "sweat" at night,
so keep it away from delicate furnishings or
expensive wallpaper!

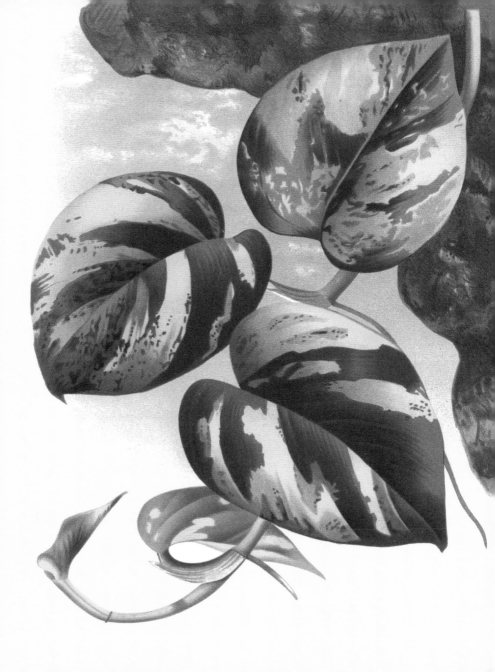

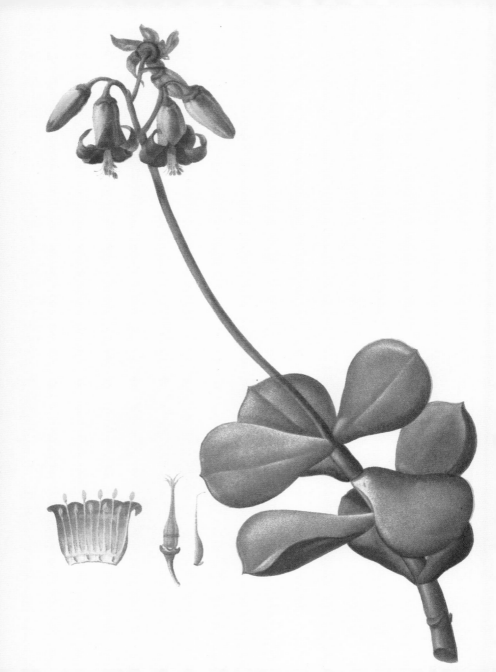

Cotyledon orbiculata

round-leafed navel-wort, pig's ear
by Pierre Joseph Redouté from Augustin
Pyramus de Candolle and Pierre Joseph
Redouté *Plantarum Historia Succulentarum,*
1798–1837

Growing succulents is a tactile experience,
rather than a scientific one. The leaves of this
South African native store water as a way to deal
with drought. If overwatered, the leaves will
burst open, so only water the plant if its leaves
feel floppy or wrinkly.

Piper nigrum

black pepper
by Janet Hutton from the Kew Collection, 1820

Originally from India, black pepper has been
a widely traded spice for millennia, serving as
both flavouring and medicine. It was considered
so common that its name came to signify
any low value attributed nominally for legal
purposes, e.g. "peppercorn rent".

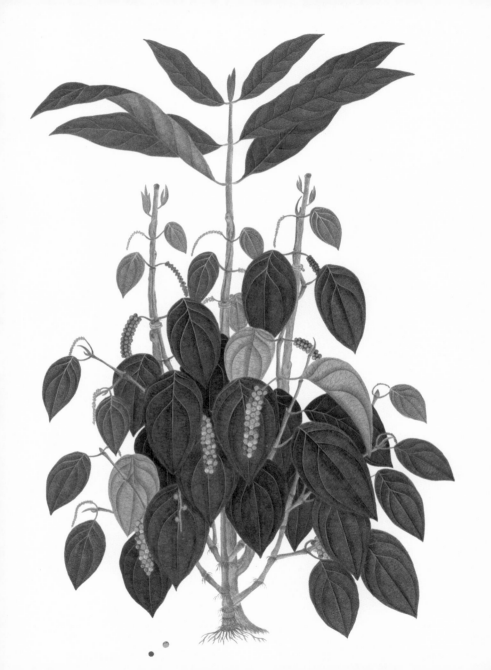

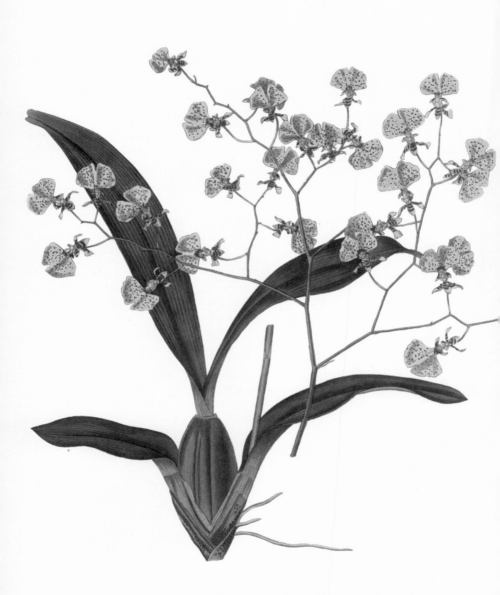

Gomesa flexuosa

golden rain, dancing-doll orchid
from *Curtis's Botanical Magazine,* 1821

The golden rain, or *lluvia de oro* in Spanish,
is an epiphyte native to Brazil and Argentina.
Epiphytes are not parasitic but live on tree
branches to access more sunlight than they
would receive on the forest floor. Epiphytic
communities in rainforests are often very
complicated and support many animal species.

Monstera deliciosa

Swiss cheese plant
from *Berliner Allgemeine Gartenzeitung*, 1857

No one can decide why this famously holey
plant looks the way it does. Are the holes
there to let light penetrate to its lower leaves
or allow the leaves to fit around other plants
like a solar panel jigsaw puzzle? Maybe they
lessen the damage to this rampant climber
from hurricanes; or do holes just make it
look unappetising to predators?

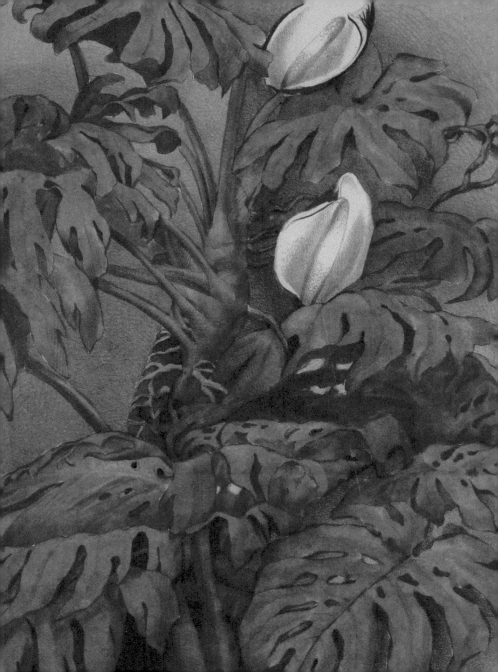

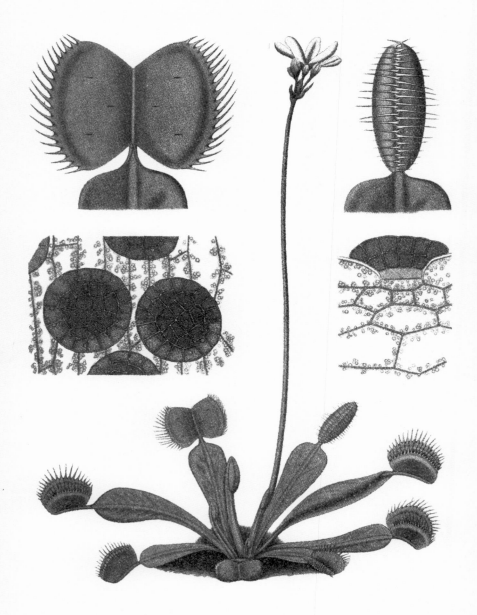

Dionaea muscipula

Venus fly trap
from *Botanische Wandtafeln*, 1874–1911

To make sure that it only eats the freshest flies, the Venus fly trap has a series of hairs inside its traps that act like trip wires. If these are activated twice within 20 seconds, the trap will snap shut and begin digesting the fly within. This action takes a lot of effort for the plant, so don't try to feed it dead flies or bits of paper!

Medinilla magnifica

rose grape
from the Marianne North Collection, Kew, 1870

This incredibly flamboyant plant can grow quite quickly in a bright and humid environment, so prune it back after flowering. Always cut just above a node (joint), using clean tools to minimise the risk of infection and allow the plant to heal quickly.

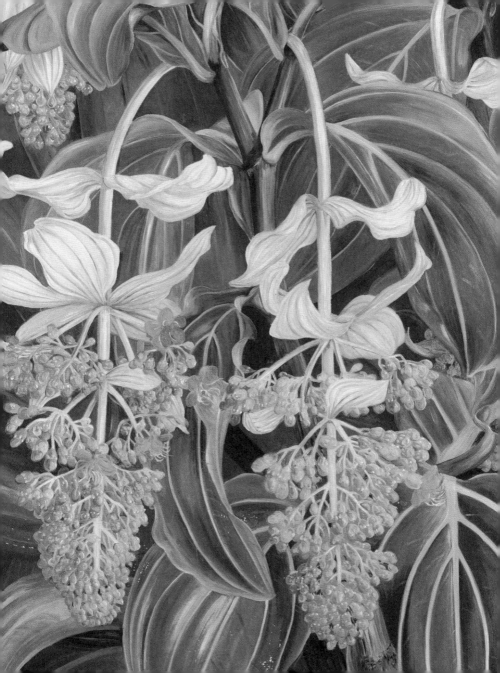

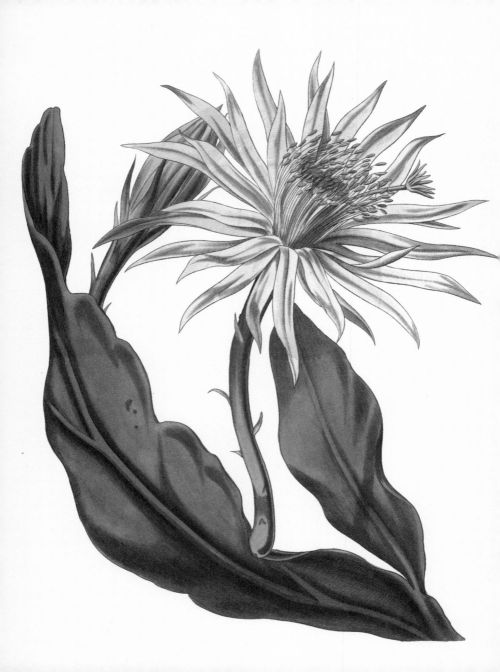

Epiphyllum oxypetalum

queen of the night
by Walter Hood Fitch from
Curtis's Botanical Magazine, 1841

The queen of the night flower has been the focus
of many myths and folktales, from its native
Mexico to India and beyond. It is much lauded
around the world for its rarity, and its sweet,
fleeting, nocturnal flowers symbolise beauty,
femininity and love.

Nephrolepis exaltata

Boston fern
from Edward Joseph Lowe
Ferns: British and exotic, 1839

The Boston fern prefers a humid environment
and will drop leaves to show its displeasure.
Display on a shelf or in a hanging basket to
show off the long, drooping fronds and
fluffy root tendrils.

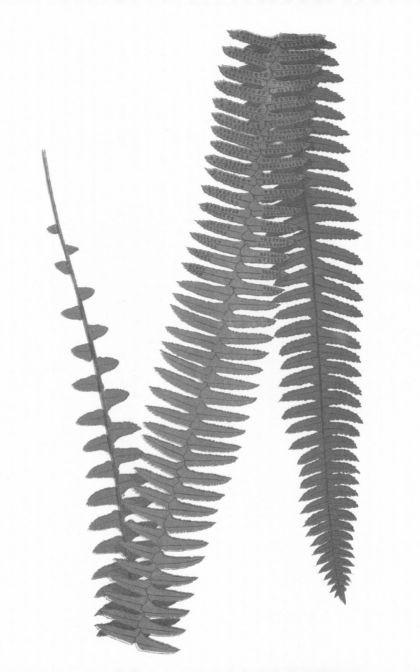

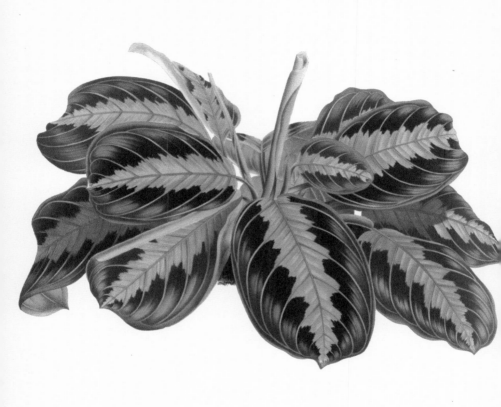

Maranta leuconeura

prayer plant
from *Flore des Serres et des
Jardins de l'Europe*, 1877

Maranta have a wrist-like joint in their stems
called a pulvinus. This thick, rough area of stem
allows the leaves to follow the sun. Some plants
hold their leaves completely upright in a resting
position at night or in extreme heat — hence
the name "prayer plant".

Phalaenopsis species

moth orchid
by John Nugent Fitch from Robert Warner
and Benjamin Samuel Williams
The Orchid Album, 1882–97

One of the most popular orchids around today,
this plant thrives on neglect. When the flowers
eventually fade, cut the flower stalk near the
base, just above a node (joint), to encourage
new flowers to grow.

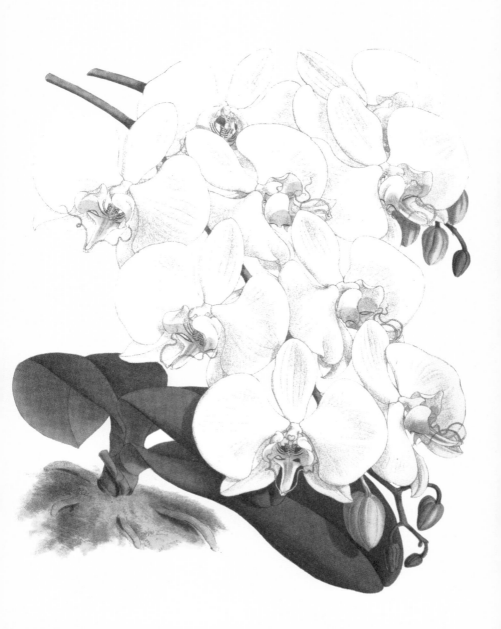

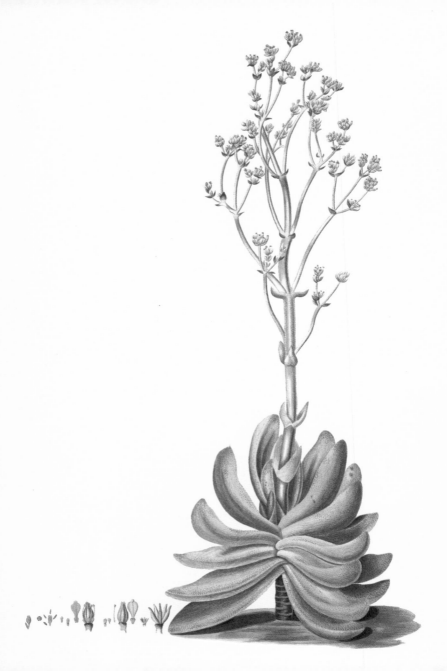

Crassula ovata

money tree, jade plant
from Christopher Jacob Trew
Plantae Rariores, 1763

This plant looks particularly bewitching in
maturity, when it takes on the gnarled look
of a large bonsai. The leaves are very easy
to knock off, so be careful, especially when
removing pests. If you want more plants,
save any leaves that are dislodged and lay
them out on the windowsill to root before
planting them in compost.

Sarracenia purpurea

purple pitcher plant, common pitcher
from *Gartenflora*, 1867

As with all carnivorous plants, *Sarracenia*
should only be watered with treated water
and never fed. They are so well adapted to
living in nutrient poor environments that
any extras may harm them. Keep in a cool,
bright spot if possible.

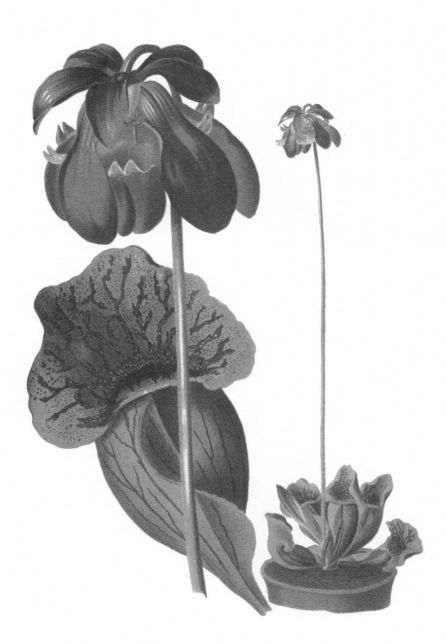

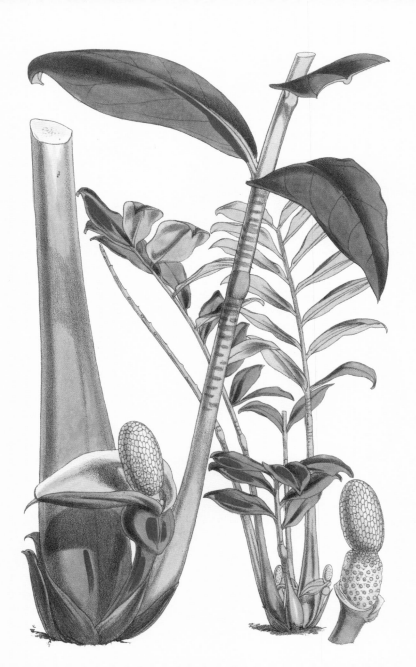

Zamioculcas zamiifolia

fern arum
by Walter Hood Fitch from
Curtis's Botanical Magazine, 1872

———————

The perfect plant for a basement flat, the
"ZZ plant" can cope with shade and drought
quite comfortably. It is easily propagated from
leaf cuttings — just be careful with the sap as it
may cause skin reactions.

Strelitzia nicolai

bird of paradise
by Matilda Smith from
Curtis's Botanical Magazine, 1889

———————

One of the largest forms of bird of paradise
plant, this species can grow up to 8 m (26 ft) tall.
It has a huge flower up to 50 cm (20 in) long of
deep black, with white and blue plumes.

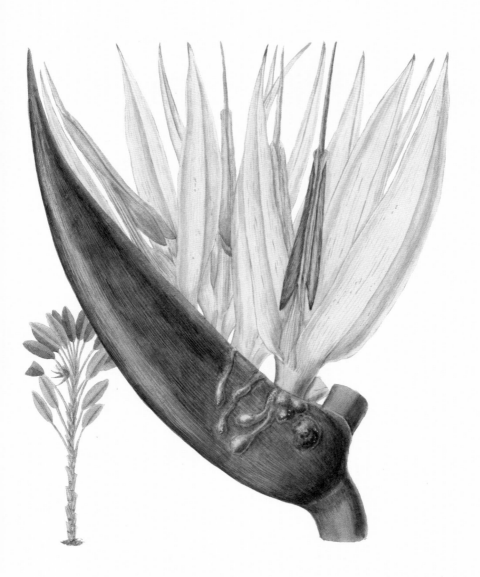

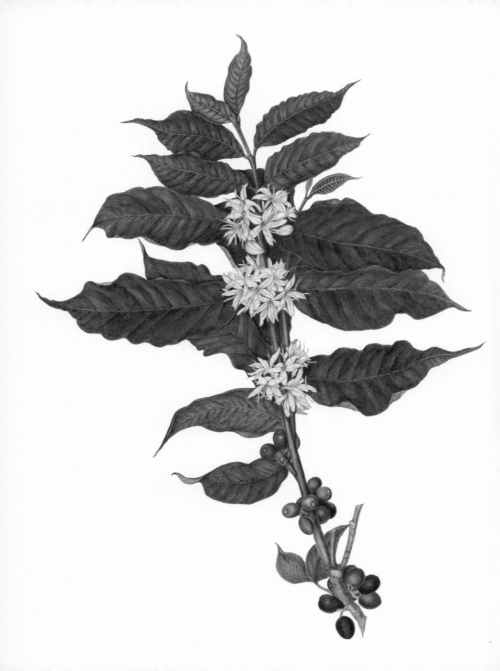

Coffea arabica

coffee
from the Tankerville Collection, Kew,
1756–1824

Often sold as seedlings, these plants will take a
few years to reach maturity but are well worth
the wait. The shrub has deep green, wavy leaves
with branches covered in sweet white flowers.
The beans we know and love are borne on the
branches as beads of red and green coffee fruits.

Begonia maculata

spotted begonia, polka dot begonia
from Johann Heinrich Friedrich Link and
Friedrich Otto *Icones Plantarum Selectarum
Horti Regii Botanici Berolinensis*, 1828

Begonias are one of the easiest plants to
propagate. Simply take a leaf, score it across
some of the veins and pin it directly onto a tray
of damp soil. Pop into a plastic bag to keep the
humidity up, place on a windowsill and wait.

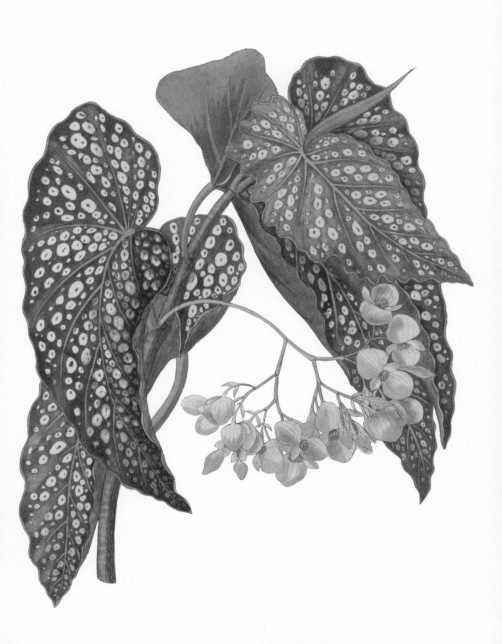

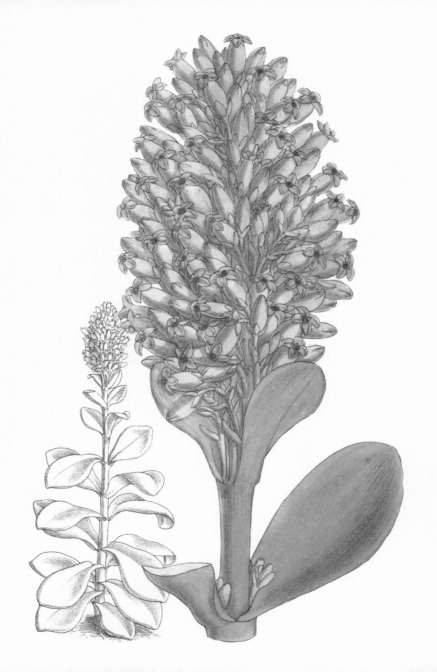

Kalanchoe thyrsiflora

paddle plant
by Matilda Smith from
Curtis's Botanical Magazine, 1899

Native to Southern Africa, this succulent is a
great plant for a beginner gardener. Keep away
from direct sunlight and water sparingly.

Anthurium andraeanum

flamingo flower
from *l'Illustration Horticole*, 1877

This structural beauty is easy to care for and can provide cut flowers all year round. Keep away from pets and children, though. *Anthurium*, like many others in the Araceae family, are toxic and may cause allergic reactions.

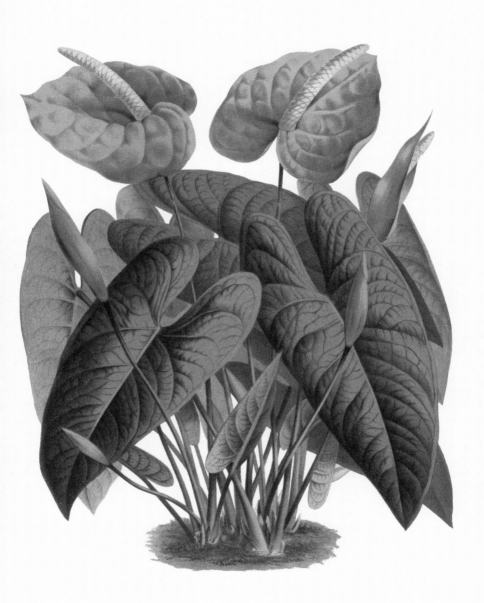

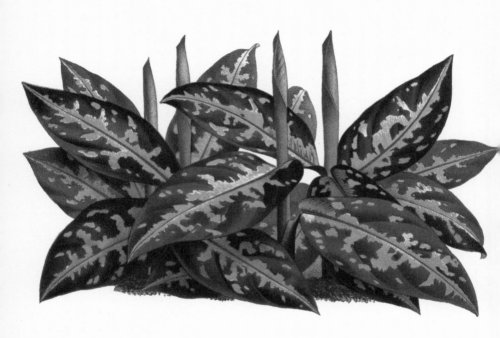

Nº 38

Aglaonema pictum

from *l'Illustration Horticole*, 1882

Native to the volcanic slopes of Sumatra, this
plant can be a little tricky to care for. Ensure it
is kept in a warm space away from draughts
and cold windows as it can develop cold
damage from as little as 15°C (59°F)!

Aloe vera

aloe vera, Barbados aloe
from Joseph Roques
Phytographie Médicale, 1821

Aloe vera may have been first used as much as
four millennia ago by the Ancient Egyptians.
Famous as a treatment for almost any
skin condition, it is also now an important
economical crop in many parts of the world.

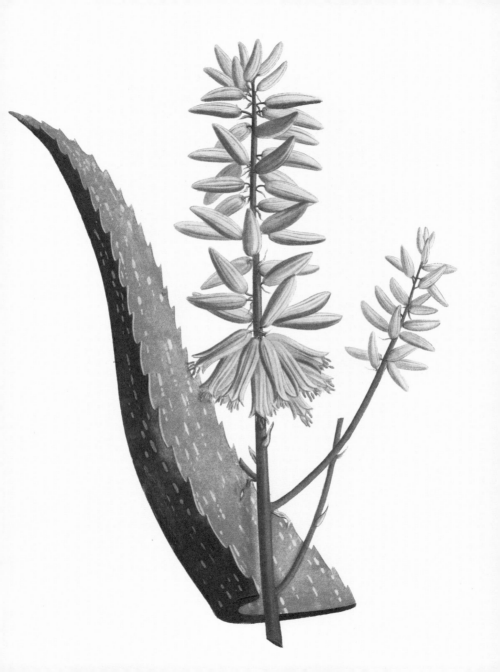

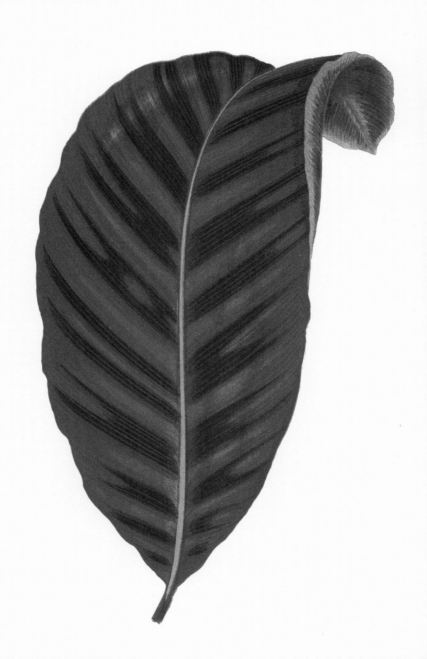

Goeppertia zebrina

zebra plant
from Edward Joseph Lowe
Beautiful Leaved Plants, 1868

The stunning striped foliage on this herbaceous
perennial is even more notable than its deep
purple flowers. Keep moist and in partial
shade to achieve the largest leaves. They
can sometimes reach 30 cm (1 ft) or
more in length!

ILLUSTRATION SOURCES

Books and Journals

Candolle, A. D. de and Redouté, P. J. (1798-1837). *Plantarum Historia Succulentarum*. Volume 1. A. J. Dugour et Durand, Paris.

Commelijn, C. (1703). *Praeludia Botanica*. Fredier Harigh, Lyon.

Curtis, S. (1841). *Epiphyllum oxypetalum. Curtis's Botanical Magazine*. Volume 67, t. 3813.

Curtis, S. (1834). *Ficus benjamina. Curtis's Botanical Magazine*. Volume 61, t. 3305.

Grey-Wilson, C. (1984). *Pilea peperomioides. Curtis's Botanical Magazine*. Volume 1, t. 5.

Hooker, J. D. (1899). *Kalanchoe thyrsiflora. Curtis's Botanical Magazine*. Volume 125, t. 7678.

Hooker, J. D. (1874). *Mesembryanthemum truncatellum. Curtis's Botanical Magazine*. Volume 100, t. 6077.

Hooker, J. D. (1895). *Saintpaulia ionantha. Curtis's Botanical Magazine*. Volume 121, t. 7408.

Hooker, J. D. (1889). *Strelitzia nicolai. Curtis's Botanical Magazine*. Volume 115, t. 7038.

Hooker, J. D. (1877). *Tillandsia usneoides. Curtis's Botanical Magazine*. Volume 103, t. 6309.

Hooker, J. D. (1872). *Zamioculcas zamiifolia. Curtis's Botanical Magazine*. Volume 98, t. 5985.

Hooker, W. J. (1848). *Hoya lanceolata. Curtis's Botanical Magazine*. Volume 74, t. 4402.

Jacquin, J. F. von. (1811–44). *Eclogae Plantarum Rariorum aut Minus Cognitarum*. J. F. von Jacquin, Vindobona.

Kerchove de Denterghem, O. C. E. (1878). *Les Palmiers*. J. Rothschild, Paris.

Kny, C. I. L. (1874-1911). Botanische Wandtafeln. Parey, Berlin.

Koch, K. (1857). *Berliner Allgemeine Gartenzeitung*. Volume 25.

Linden, J. J. (1882). *Aglaonema pictum. l'Illustration Horticole*. Volume 29, t. 159.

Linden, J. J. (1877). *Anthurium andraeanum. l'Illustration Horticole*. Volume 24, t. 271.

Linden, J. J. (1883). *Dieffenbachia seguine. l'Illustration Horticole*. Volume 30, t. 491.

Linden, J. J. (1871). *Epipremnum aureum. l'Illustration Horticole*. Volume 27, t. 381.

Linden, J. J. (1875). *Spathiphyllum floribundum. l'Illustration Horticole*. Volume 21, t. 159.

Link, J. H. F. and Otto, F. (1828). *Icones Plantarum Selectarum Horti Regii Botanici Berolinensis*. Berlin.

Lowe, E. J. (1868). *Beautiful Leaved Plants*. Groombridge, London.

Lowe, E. J. (1839). *Ferns: British and exotic*. Volume 2, t. 5. Volume 7, t. 19. Groombridge and Sons, London.

Morren, C. (1869). *Tillandsia cyanea. La Belgique Horticole*. Volume 19, t. 18.

Regel, E.A. von (1896). *Pachira aquatica. Gartenflora*. Volume 45, t. 1422.

Regel, E.A. von (1867). *Sarracenia purpurea. Gartenflora*. Volume 16, t. 542.

Roques, J. (1821). *Phytographie Médicale*. J. Roques, Paris.

Rousselon, Libraire-Éditeur. (1833). *Annales de Flore et de Pomone*. Volume 1, t. 40.

Schumann, K., Gürke, M. and Vaupel, F. (1904–21). *Blühende Kakteen (Iconographia Cactacearum)*. Neudamm, J. Neumann, Melsungen.

Sims, J. (1821). *Oncidium flexuosum. Curtis's Botanical Magazine*. Volume 48, t. 2203.

Trew, C. J. (1763). *Plantae Rariores*. C. de Lavnoy, Nuremberg.

Van Houtte, L. (1862). *Alocasia zebrina*. Flore des Serres et des Jardins de l'Europe. Volume 15.

Van Houtte, L. (1875). *Chlorophytum capense. Flore des Serres et des Jardins de l'Europe*. Volume 21.

Van Houtte, L. (1862). *Fittonia albivenis. Flore des Serres et des Jardins de l'Europe*. Volume 15.

Van Houtte, L. (1877). *Maranta leuconeura. Flore des Serres et des Jardins de l'Europe*. Volume 22.

Van Houtte, L. (1853). *Medinilla magnifica. Flore des Serres et des Jardins de l'Europe*. Volume 9.

Warner, R. and Williams, B. S. (1882-97). *The Orchid Album*. B. S. Williams, London.

Art Collections

John Day (1824–88). An English orchid-grower and collector, who produced some 4,000 illustrations of orchids in 53 scrapbooks, dating from 1863 until his death. The scrapbooks were donated to Kew in 1902 by his sister, Emma Wolstenholme.

Marianne North (1830–90). Comprising over 800 oils on paper, showing plants in their natural settings, painted by North, who recorded the world's flora during travels from 1871 to 1885, with visits to 16 countries in 5 continents. The main collection is on display in the Marianne North Gallery at Kew Gardens, bequeathed by North and built according to her instructions, first opened in 1882.

ACKNOWLEDGEMENTS

Kew Publishing would like to thank the following for their help with this publication: Kew's Library and Archives team; Paul Little for digitisation work; Christabel King for permission to use her illustration on page 38; page 57 image from the Biodiversity Heritage Library, contributed by Harvard University Botany Libraries.

FURTHER READING

Floud, R. (2019). *An Economic History of the English Garden*. Allen Lane.

North, M. and Mills, C. (2018). *Marianne North: The Kew Collection*. Royal Botanic Gardens, Kew.

Payne, M. (2016). *Marianne North: A Very Intrepid Painter*, revised edition. Royal Botanic Gardens, Kew.

Seaton, P. (2016). *Growing Windowsill Orchids*. Second edition. Royal Botanic Gardens, Kew.

INDEX

First published in 2024
Royal Botanic Gardens, Kew,
Richmond, Surrey, TW9 3AB, UK
www.kew.org

ISBN 978 1 84246 806 7

Distributed on behalf of the Royal Botanic Gardens, Kew in North America by the University of Chicago Press, 1427 East 60th St, Chicago, IL 60637, USA.

British Library Cataloguing in Publication Data
A catalogue record for this book is available from the British Library

Design: Ocky Murray
Page layout and image work: Christine Beard
Production Manager: Georgie Hills
Copy-editing: James Kingland

Printed and bound in Italy by Printer Trento srl.

MIX
Paper | Supporting responsible forestry
FSC® C015829

Endpapers: *Fittonia albivenis*, mosaic plant, from L. Van Houtte *Flore des Serres et des Jardins de l'Europe*, 1862

p2: *Dieffenbachia seguine*, dumb cane, from Jean Jules Linden *l'Illustration Horticole*, 1883

p4: *Vriesea hieroglyphica*, king of the bromeliads, by unknown artist commissioned by Charles Jacques Edouard Morren, Kew Collection, 19th century

p10–11: *Medinilla magnifica*, rose grape, from L. Van Houtte *Flore des Serres et des Jardins de l'Europe*, 1853

For information or to purchase all Kew titles please visit shop.kew.org/kewbooksonline or email publishing@kew.org

Kew's mission is to understand and protect plants and fungi, for the wellbeing of people and the future of all life on Earth.

Kew receives approximately one third of its funding from Government through the Department for Environment, Food and Rural Affairs (Defra). All other funding needed to support Kew's vital work comes from members, foundations, donors and commercial activities, including book sales.

Publishers note about names
The scientific names of the plants featured in this book are current, Kew accepted names at the time of going to press. They may differ from those used in original-source publications. The common names given are those most often used in the English language, or sometimes vernacular names used for the plants in their native countries.